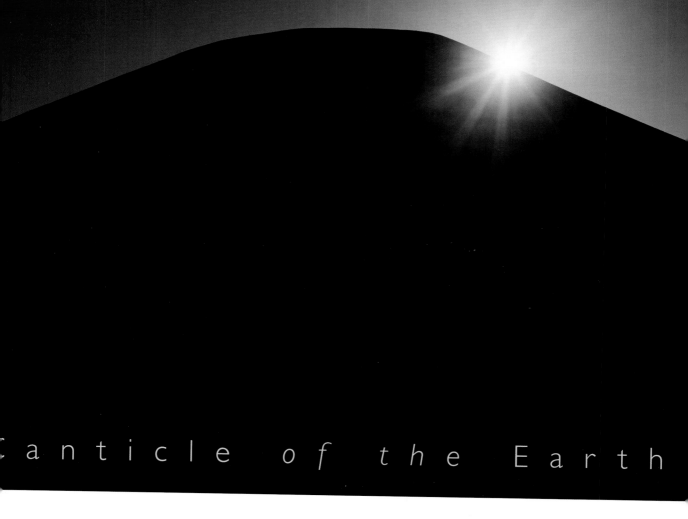

Canticle of the Earth

The words of
Francis of Assisi

anticle of the Earth

Celebrated in the photography of
David *and* Marc Muench

International Standard Book Number: 1-893732-45-2

Cover and text design by K. H. Coney

Printed and bound in Canada

Library of Congress Cataloging-in-Publication Data
Muench, David.
Canticle of the earth : the words of Francis of Assisi celebrated in the photography of David and Marc Muench.
 p. cm.
 ISBN 1-893732-45-2 (pbk.)
1. Landscape photography. 2. Nature photography. I. Muench, Marc. II. Francis, of Assisi, Saint, 1182-1226. Selections. English. 2002. III. Title.
TR660.5 .M79 2002
779'.3--dc21 2001005589
 CIP

David Muench

is a highly acclaimed landscape photographer whose works have appeared in over forty books as well as magazines, a variety of wilderness and conservation publications, and featured gallery exhibits.

Marc Muench

is a rising landscape and sports photographer. His works have been published in numerous magazines along with two volumes of photography published in collaboration with his father, David.

All *praise* be yours, my *Lord*,

in all your *creatures*.

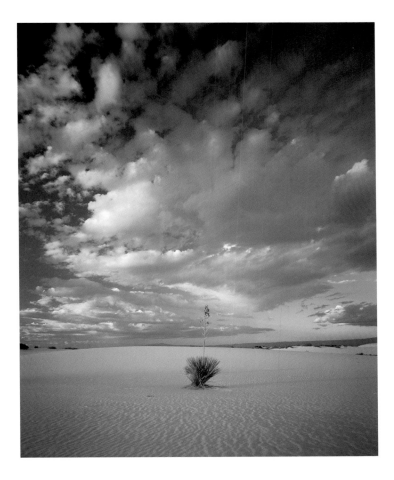

In *Brother* Sun

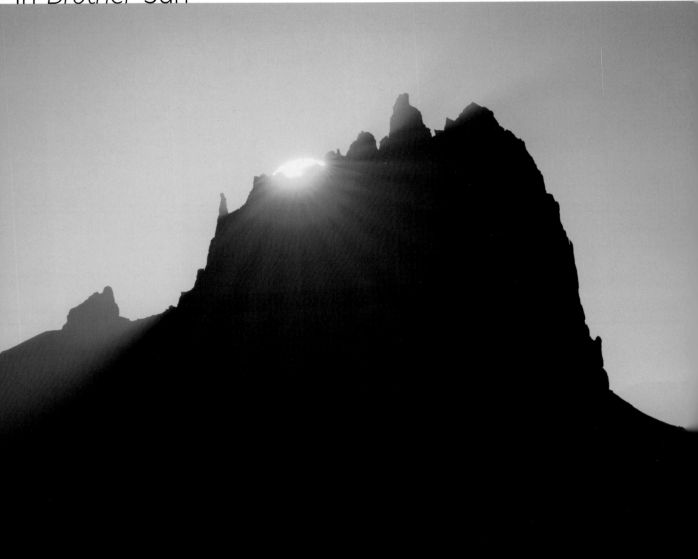

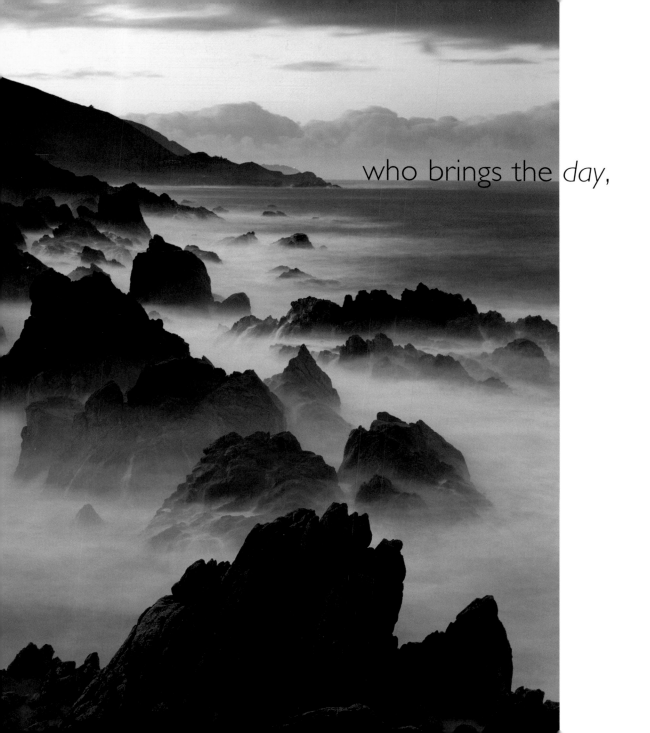

who brings the day,

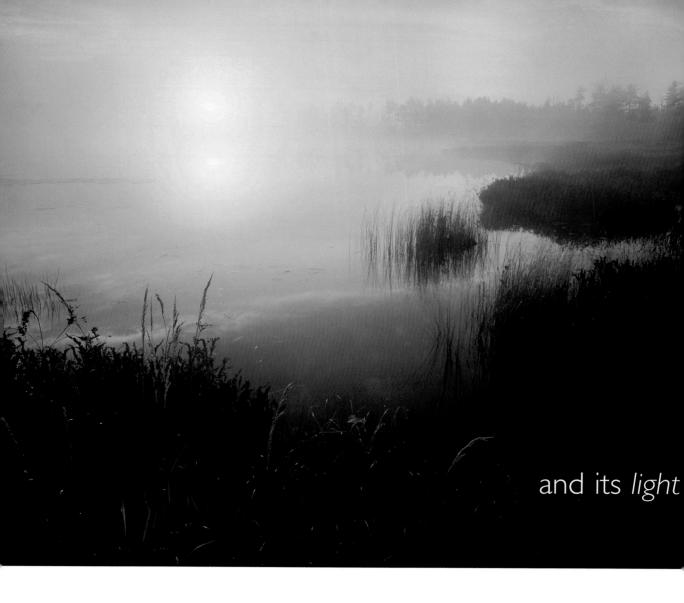

and its *light*

How *beautiful* you are, brother *sun*.

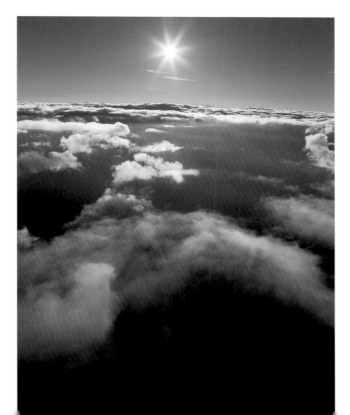

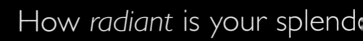

How *radiant* is your splend

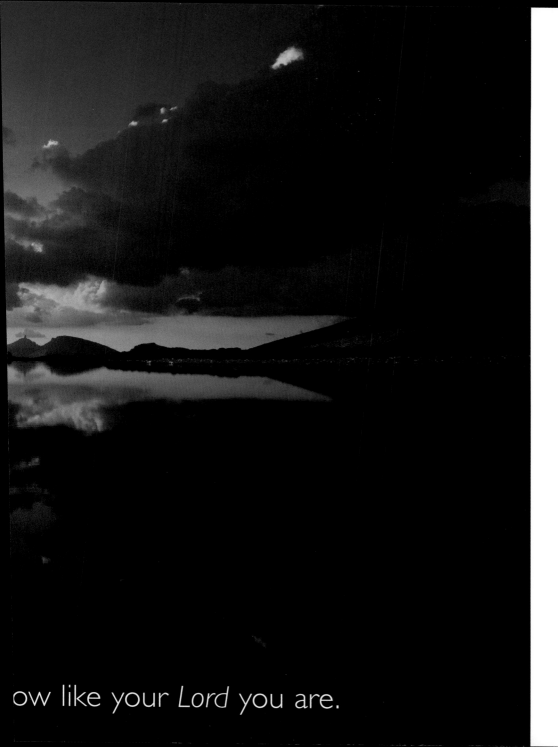

ow like your *Lord* you are.

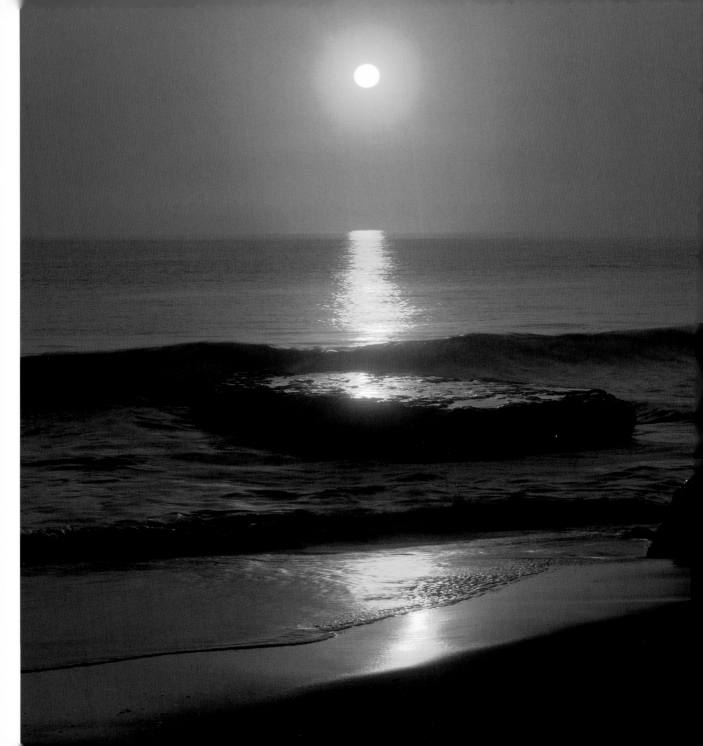

All *praise* be yours, my *Lord*,

for brother *wind,*

for the *clouds*,

and for the *day* sky.

How *beautiful* you are.

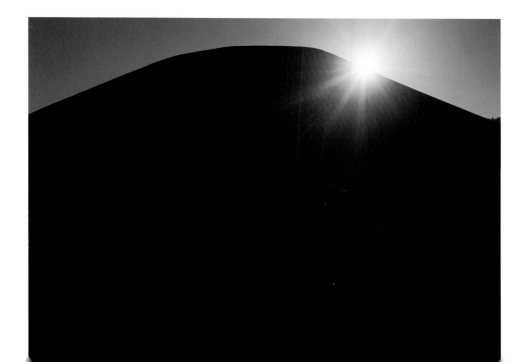

All *praise* be yours, my *Lord*,

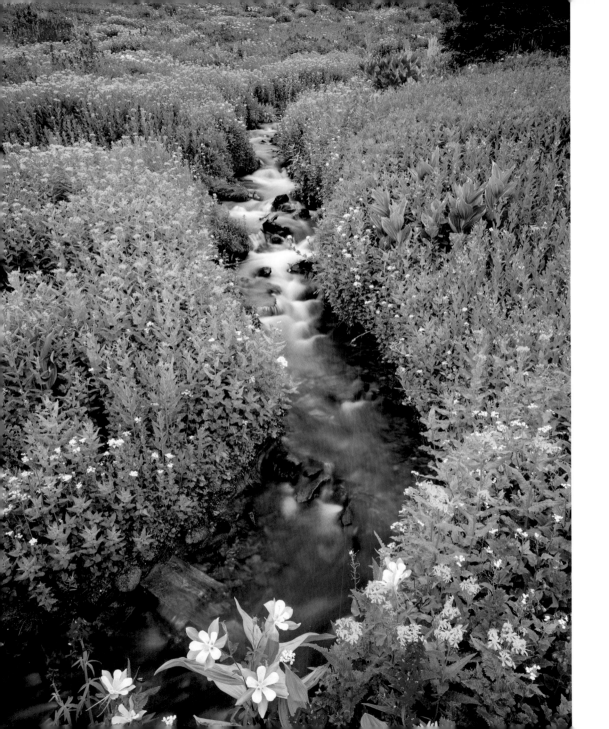

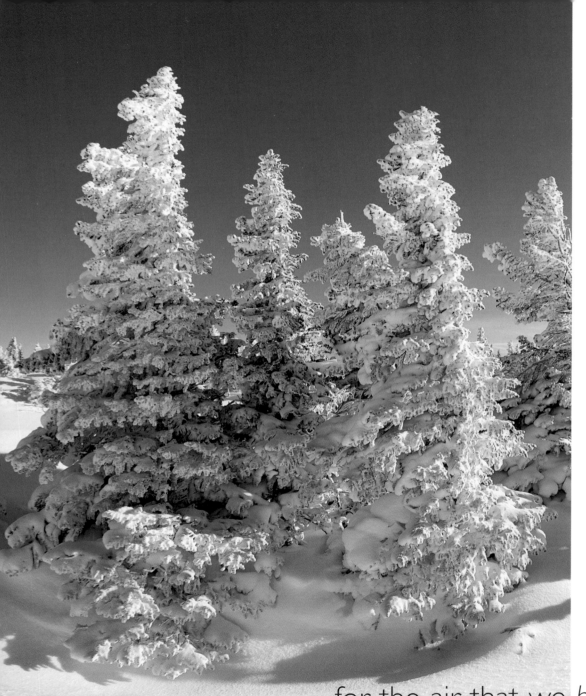

for the air that we *breathe*.

or *fair* weather,

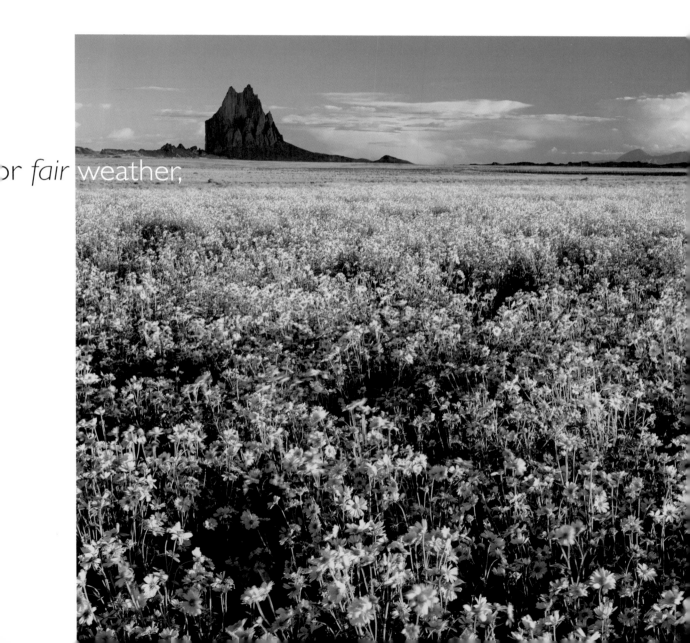

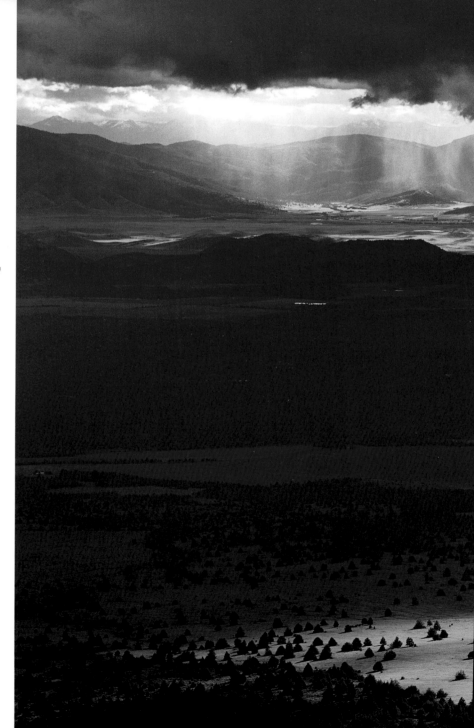

and *stormy,*

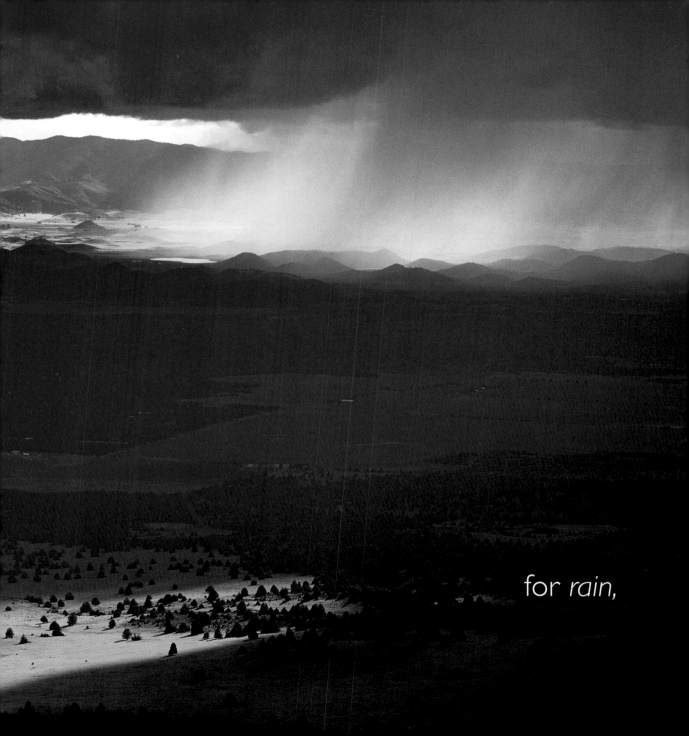

for *rain,*

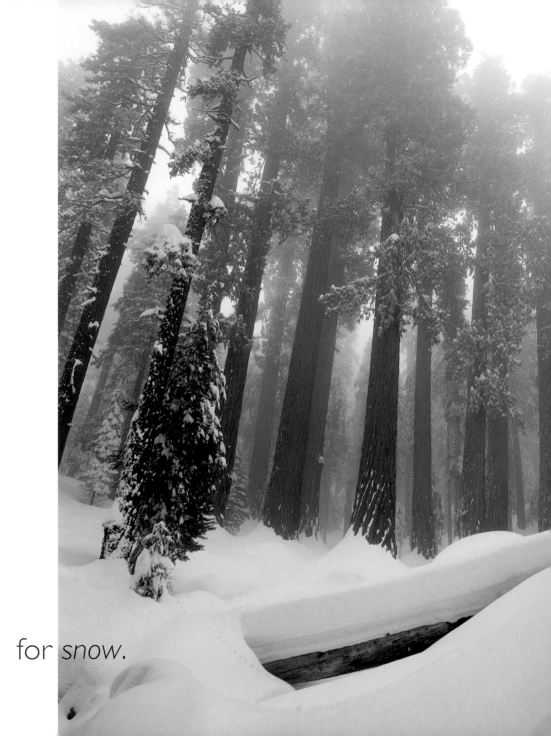

for *snow*.

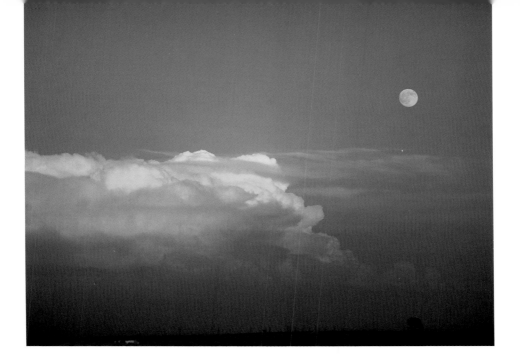

For every kind of *weather.*

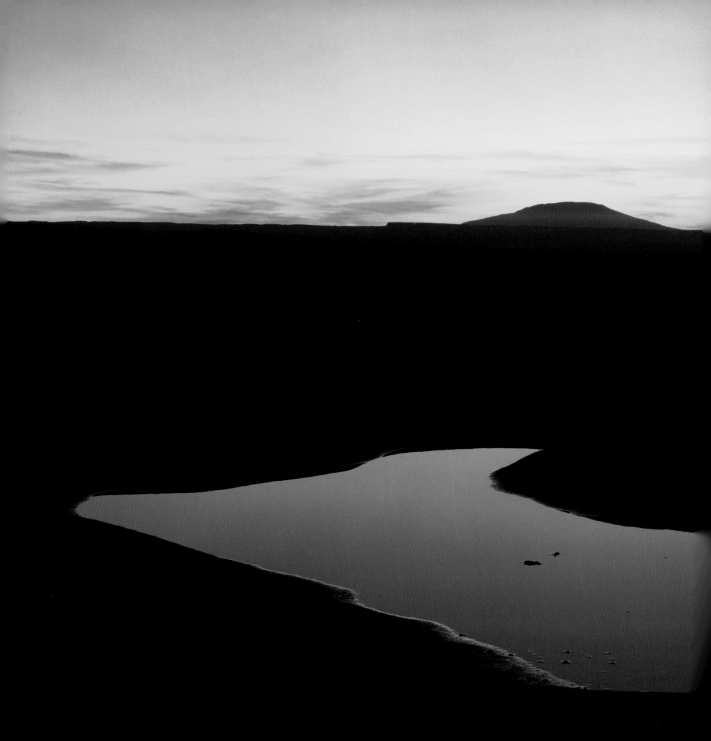

ll *praise* be yours, my *Lord,*

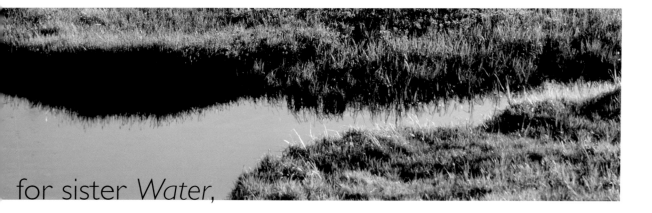

for sister *Water,*

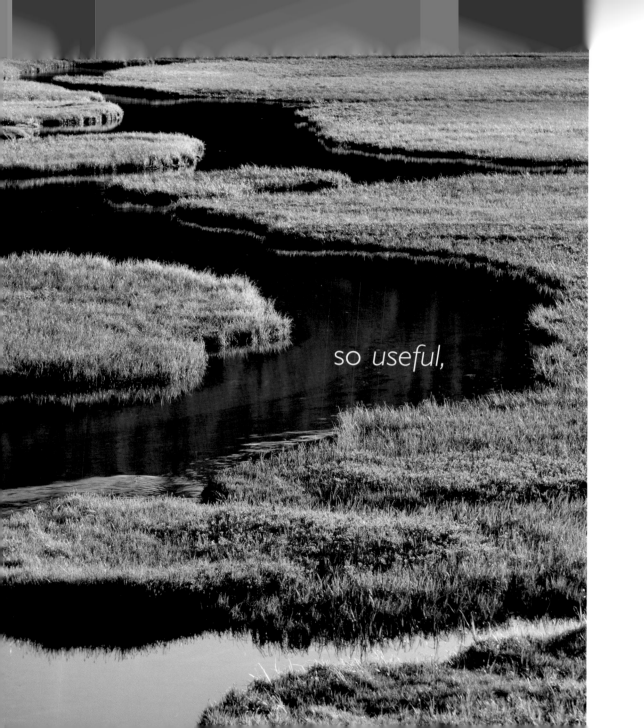

so *useful,*

so *humble,*

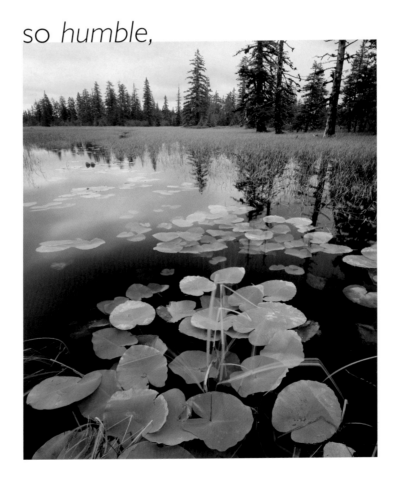

so precious and *pure*.

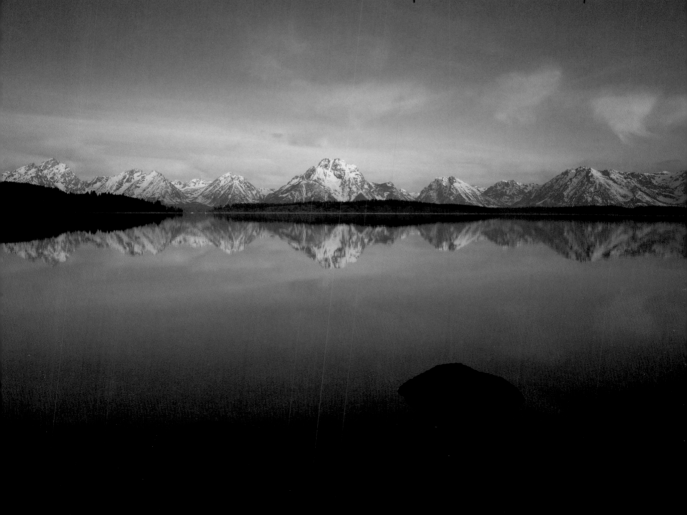

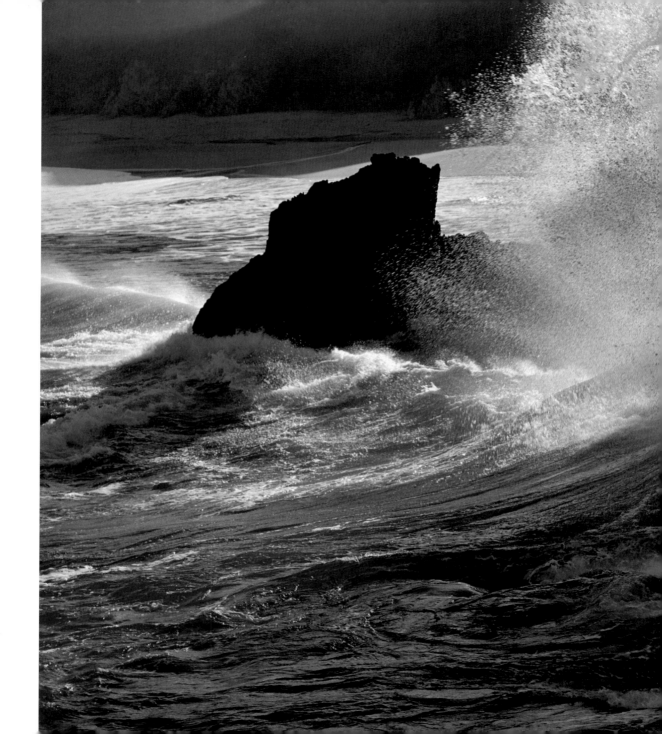

For *oceans*

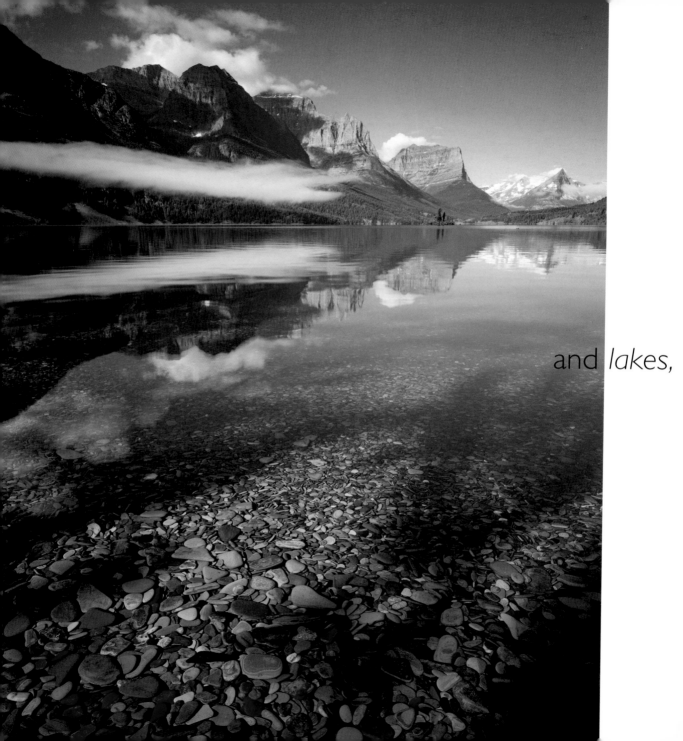

and *lakes,*

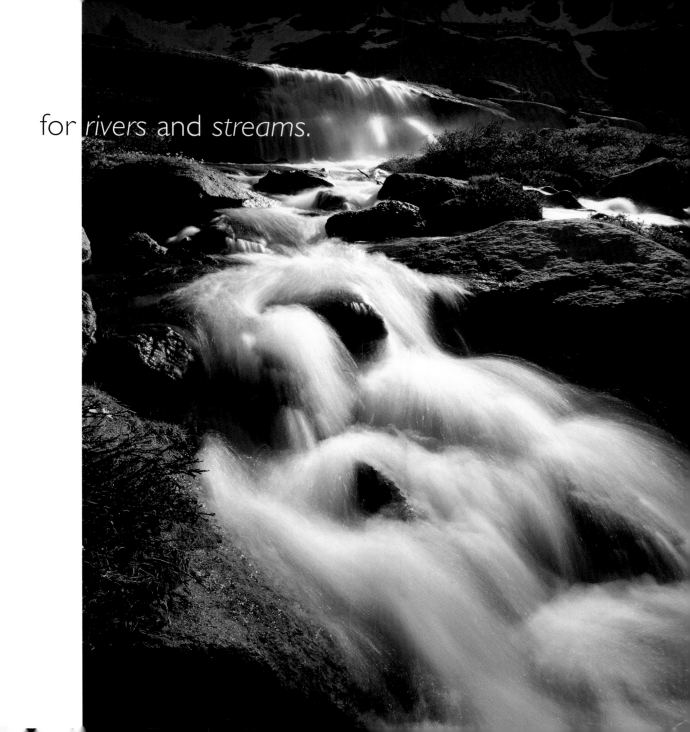

for *rivers* and *streams.*

All *praise* be yours, my *Lord,*

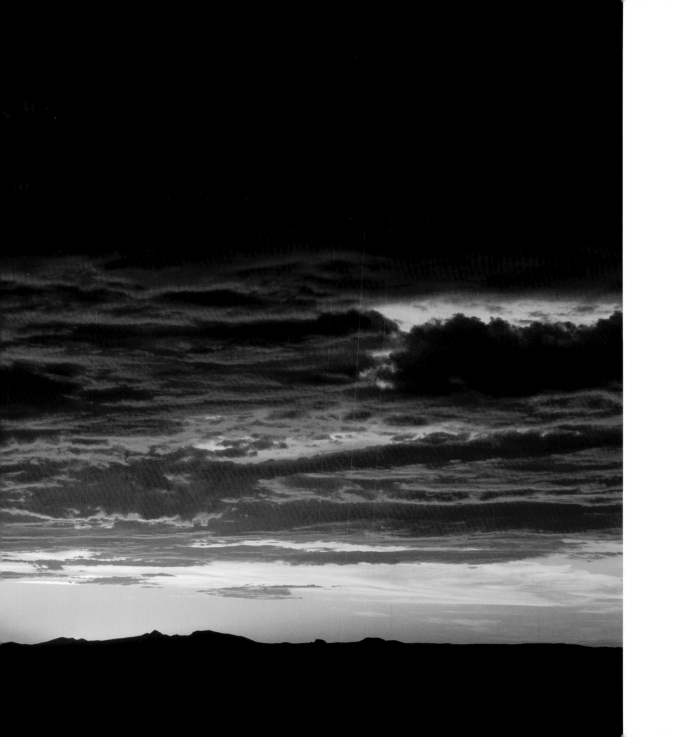

for brother *Fire,*

by whom you *brighten* the *night.*

How *beautiful* he is,

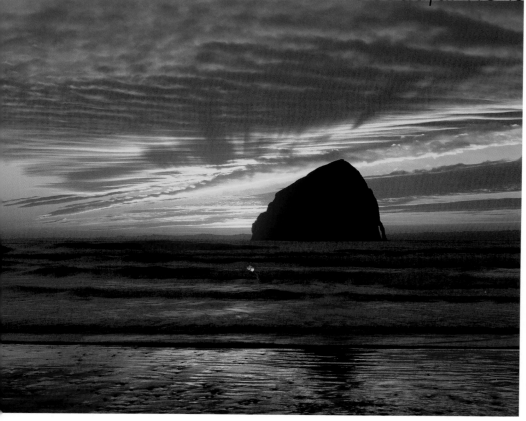

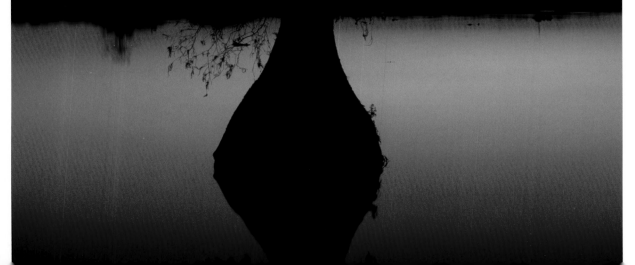

how gay, how *robust* and strong!

All *praise* be yours, my *Lord,*

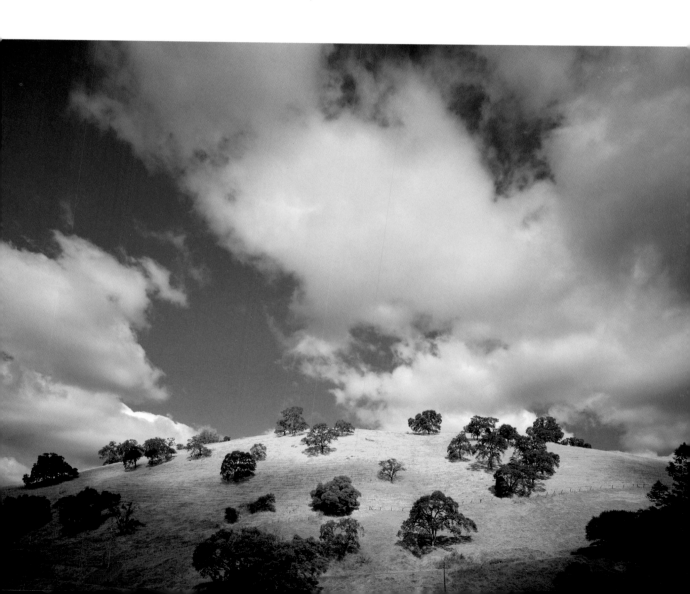

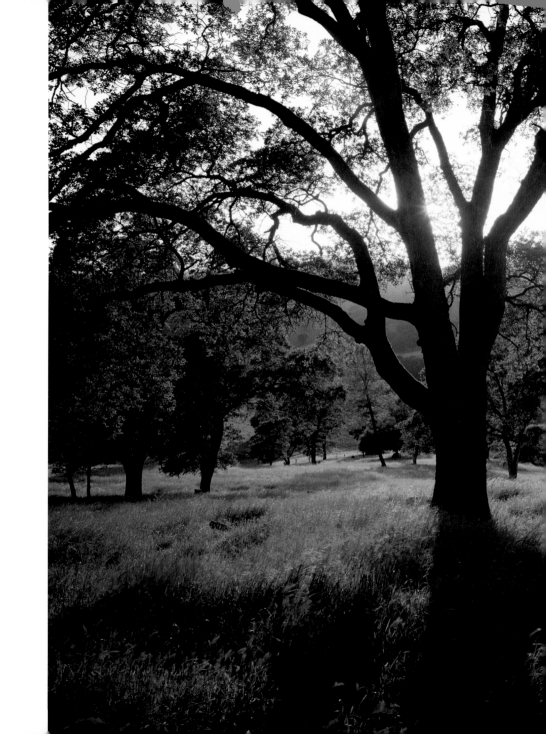

for Sister Earth, our *mother*.

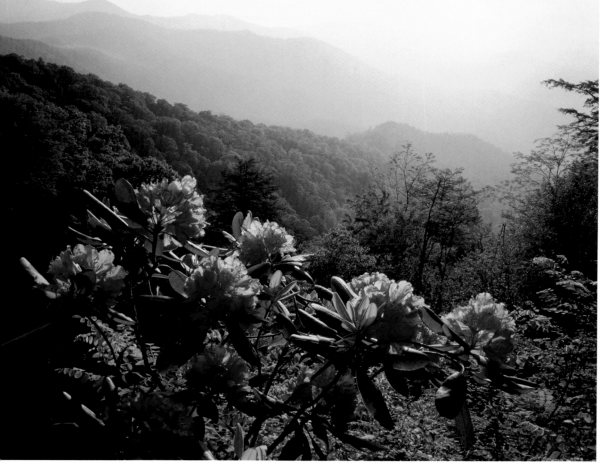

For the *mountains,*

for the *deserts,*

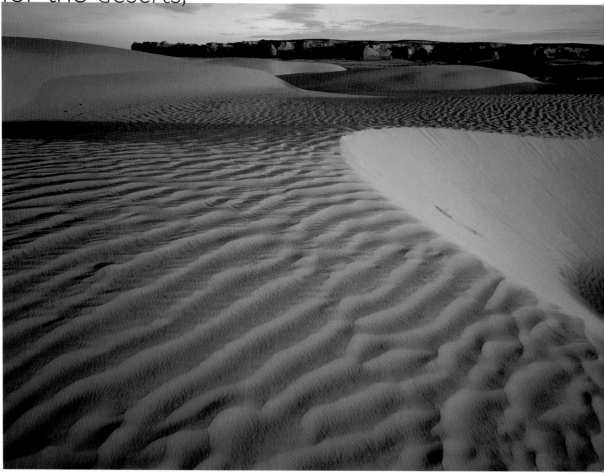

for *fields* of grain.

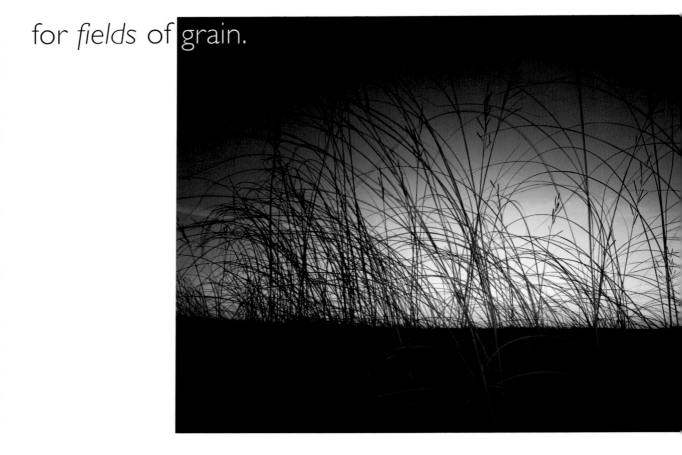

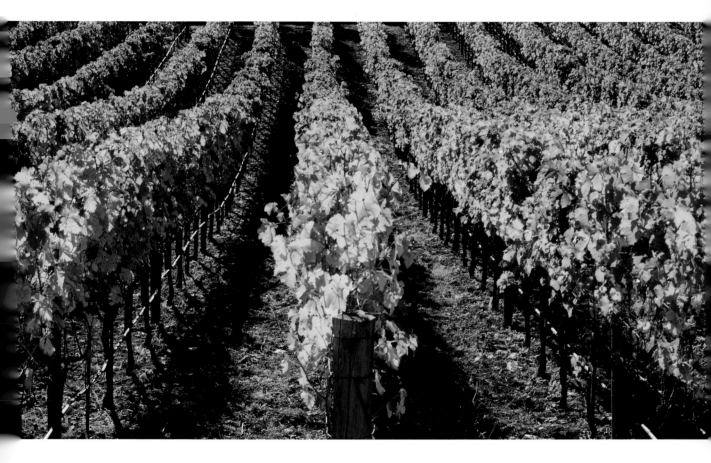

or the *land* that *nourishes* everything you have made,

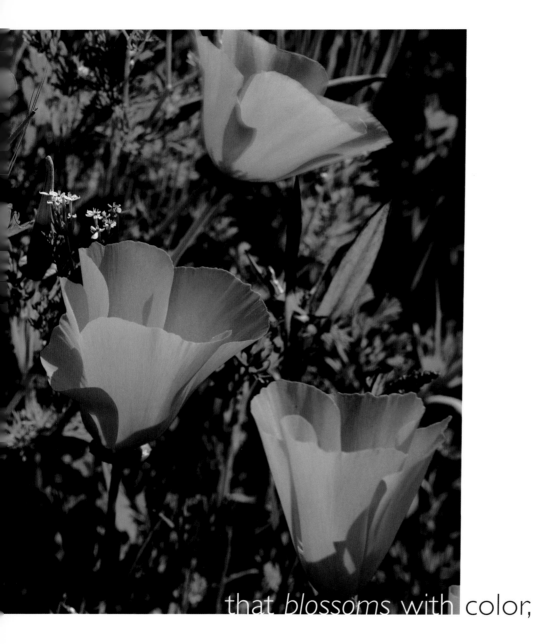

that *blossoms* with color,

that is *rich* with *fruit.*

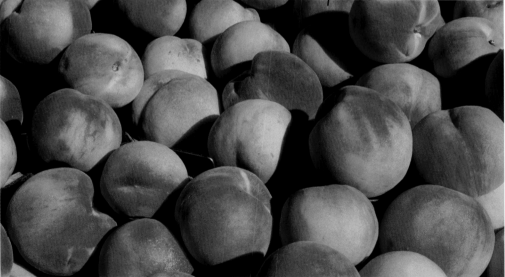

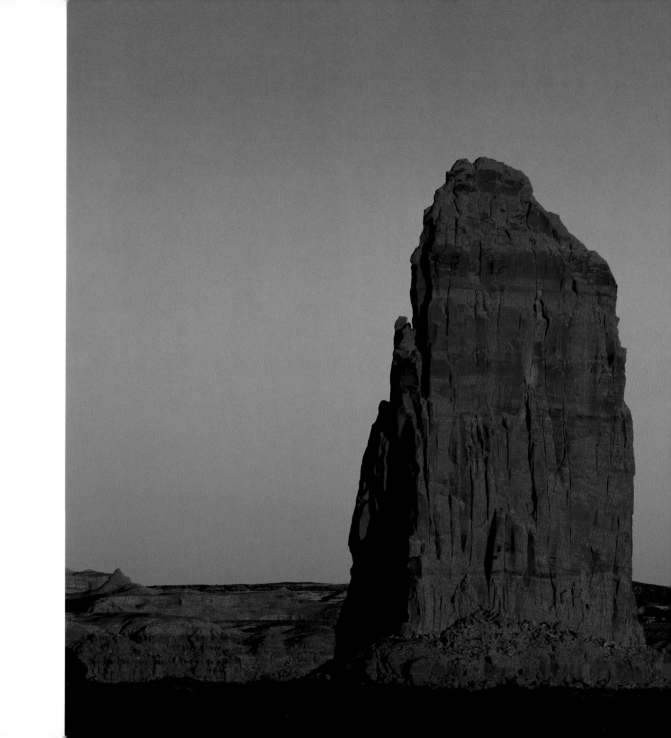

All *praise* be yours, my *Lord,*

for sister *moon,*

for the night *sky,*

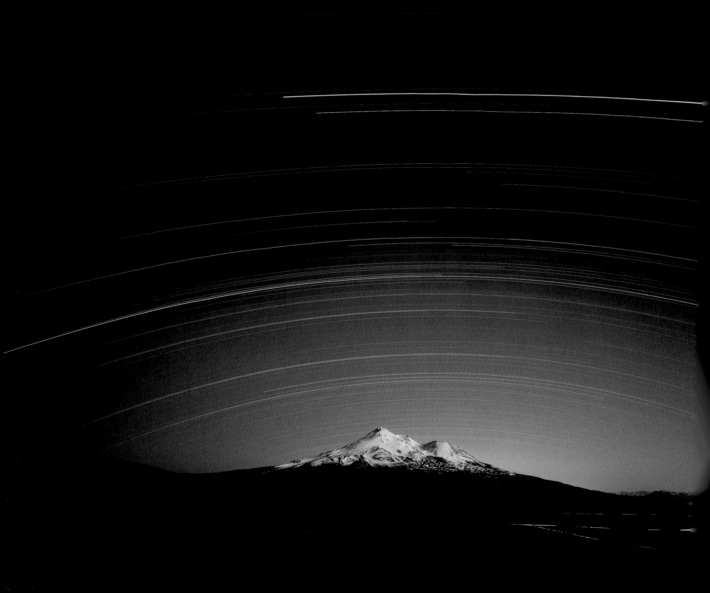

for all the *stars* in the heavens.

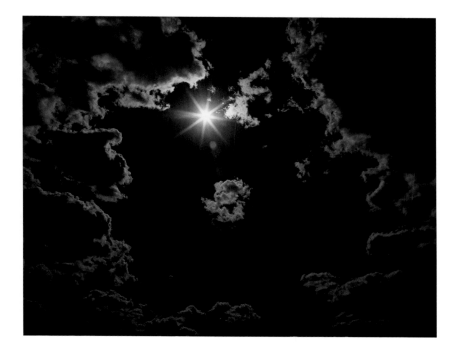

How *bright* you have made them,

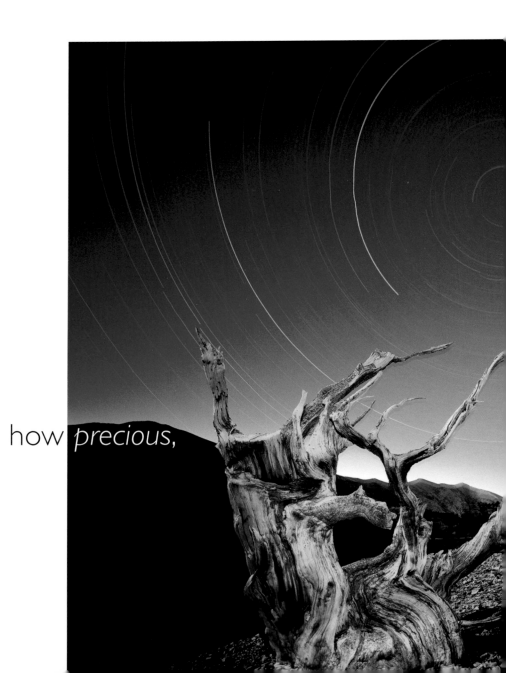

how *precious,*

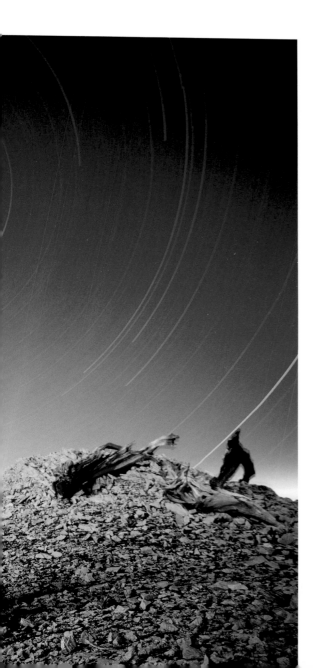

how *beautiful.*

All *praise* be yours.

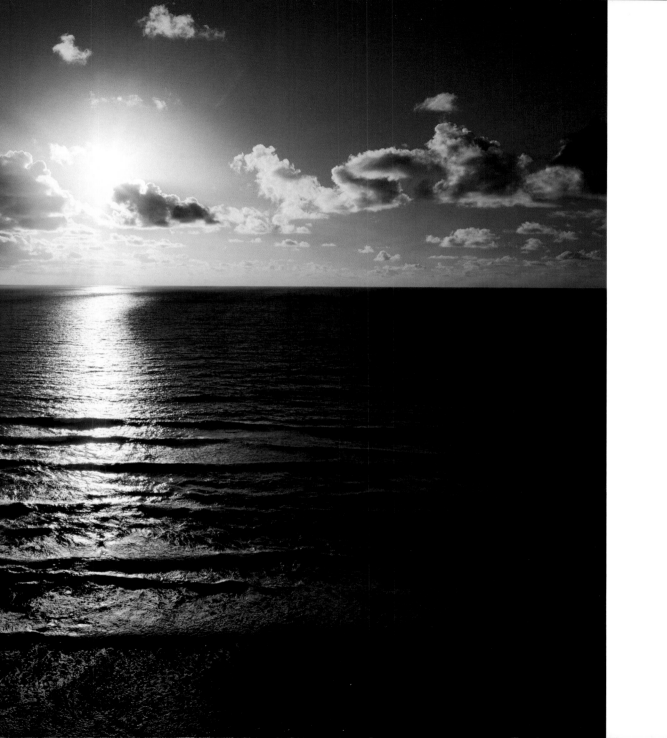

For all your creatures,

in all your creatures,

we praise you.

We give you thanks for the sun, the moon and the stars,

for the air we breathe and the land that nourishes us.

And most of all,

in each other,

for each other,

we thank and praise you,

the Lord of creation.